LIKE, TOTALLY 80'S

COLORING BOOK

BY DANI KATES

26 PAGE COLORING BOOK

Hi!

My name is Dani and I'm the girl who illustrated this coloring book. I grew up in the 80's and I wish I could go back!

I hope you enjoy coloring the pages as much as I enjoyed drawing them.

IF YOU LOVE IT, PLEASE LEAVE ME A REVIEW ON AMAZON!

As a THANK YOU

I will make you a coloring page with your name and a few of your favorite things.

Just visit my website **WWW.COLORWITHDANI.COM** and send me a message with your request and link to your review!

Thank you and have fun coloring!

xoxo,
Dani Kates

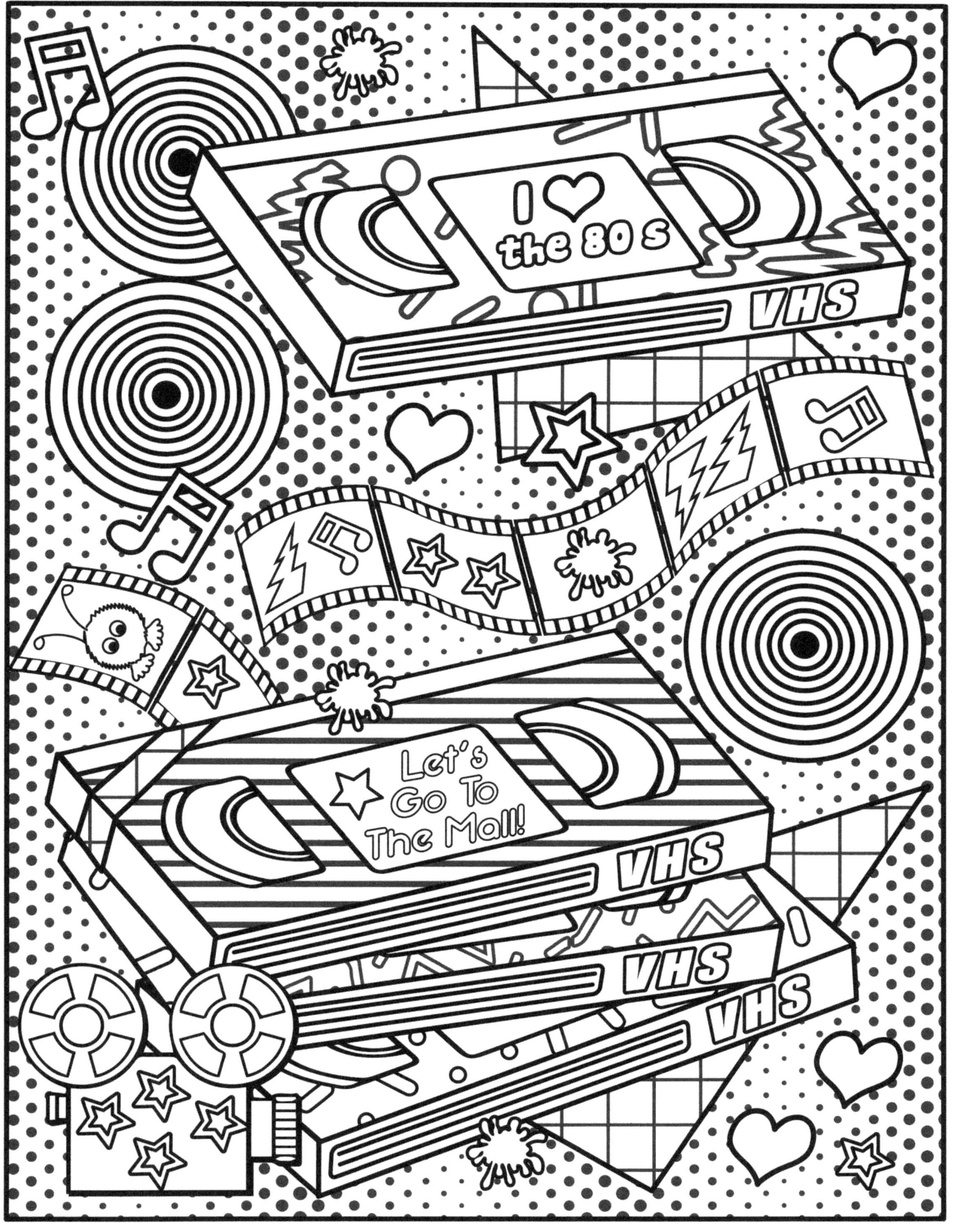

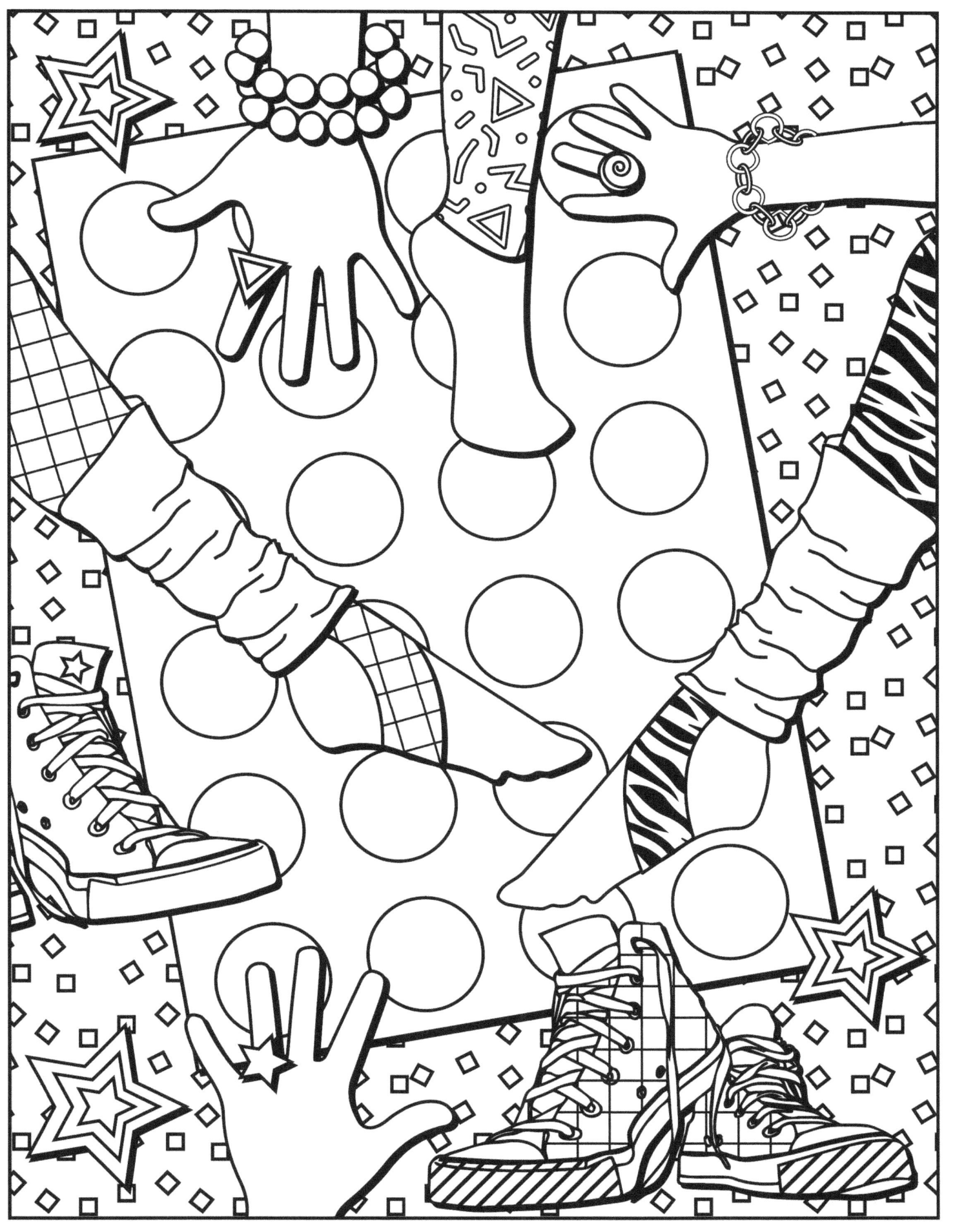

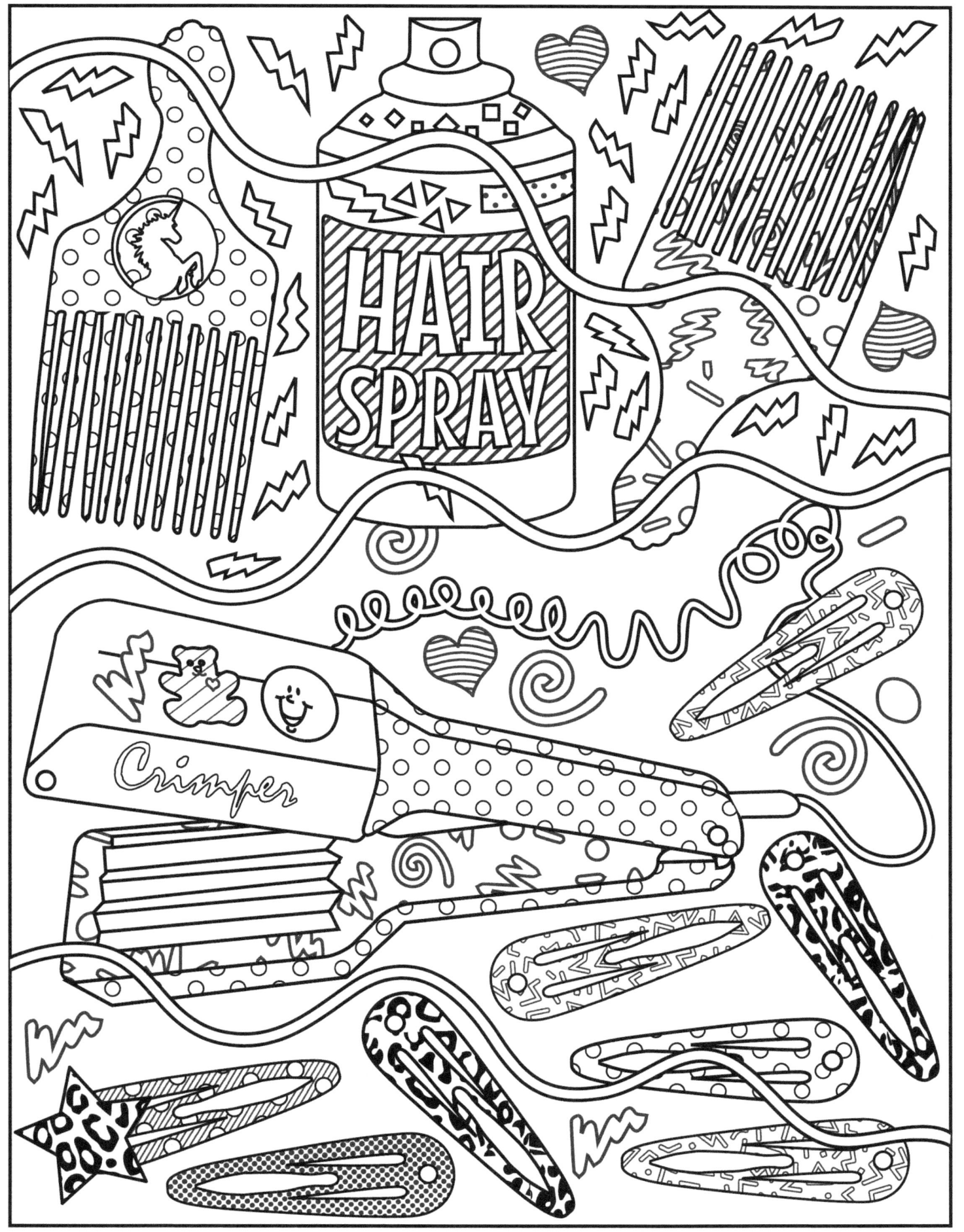

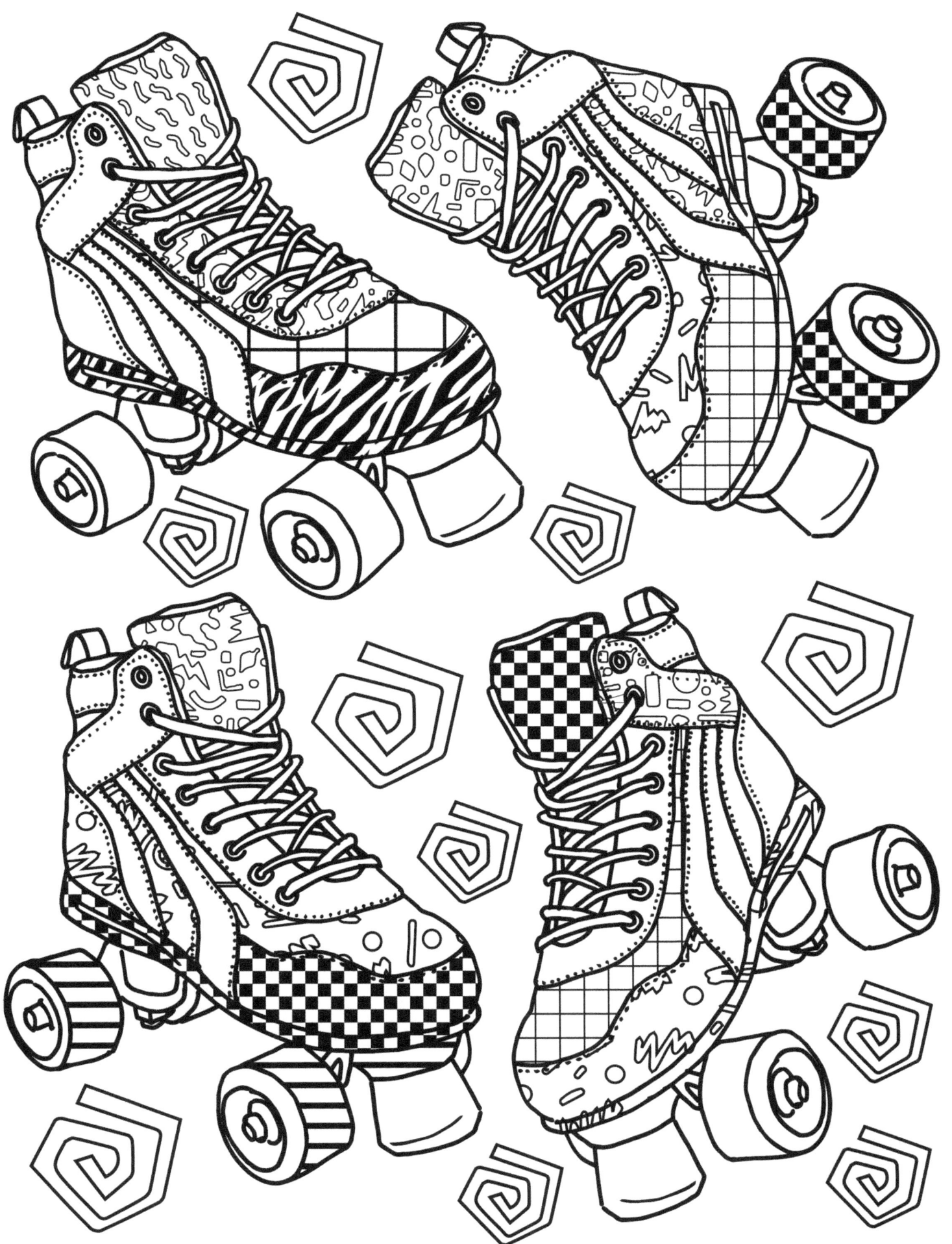

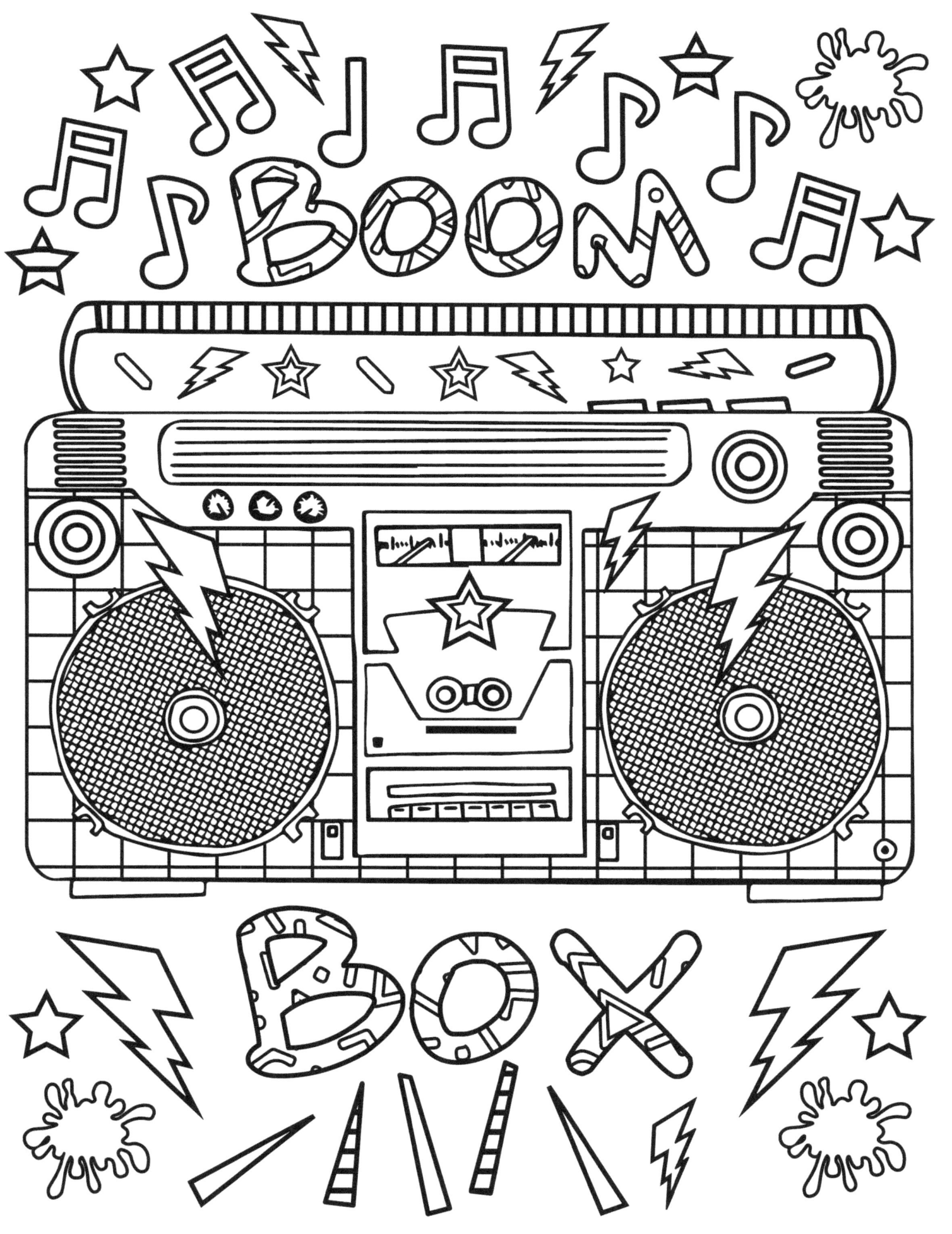

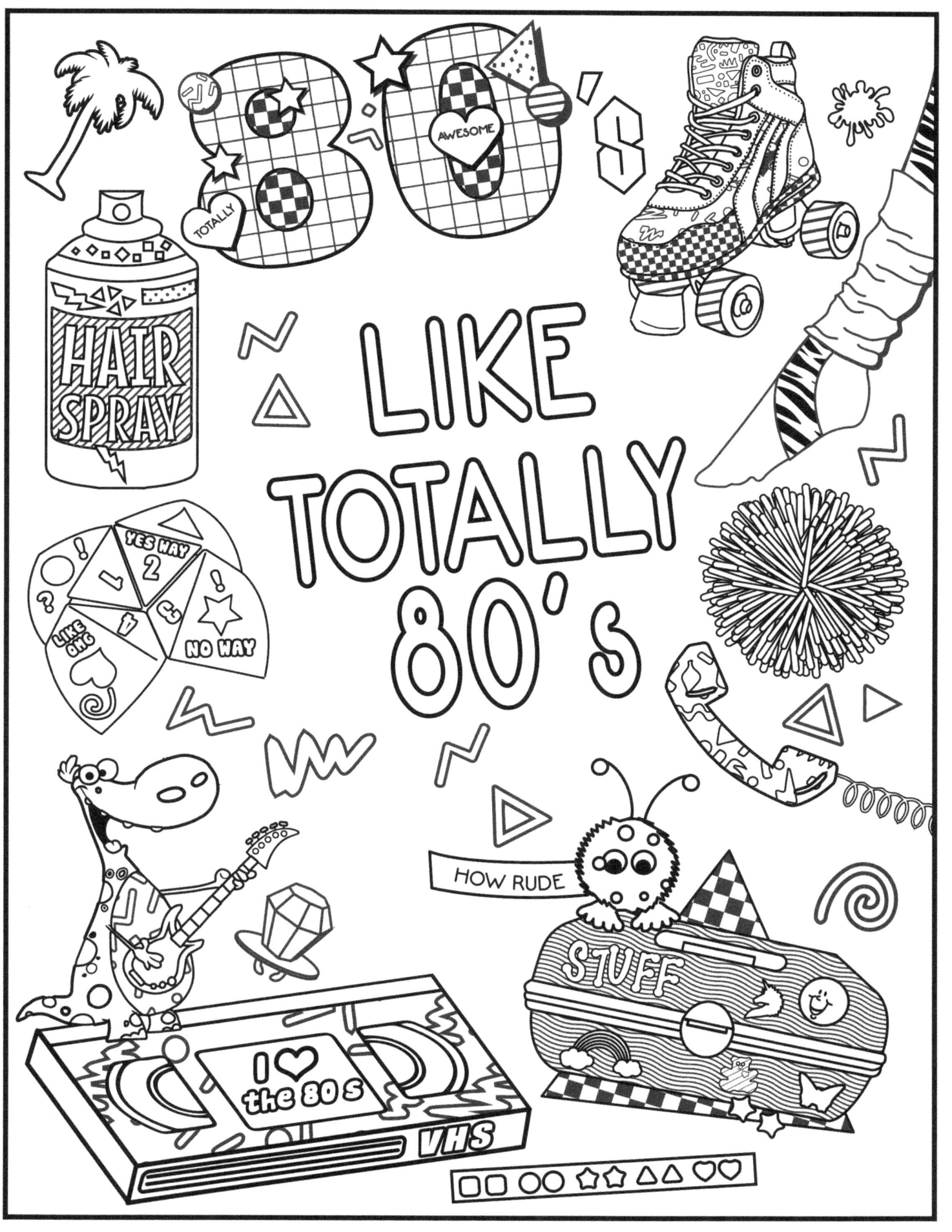

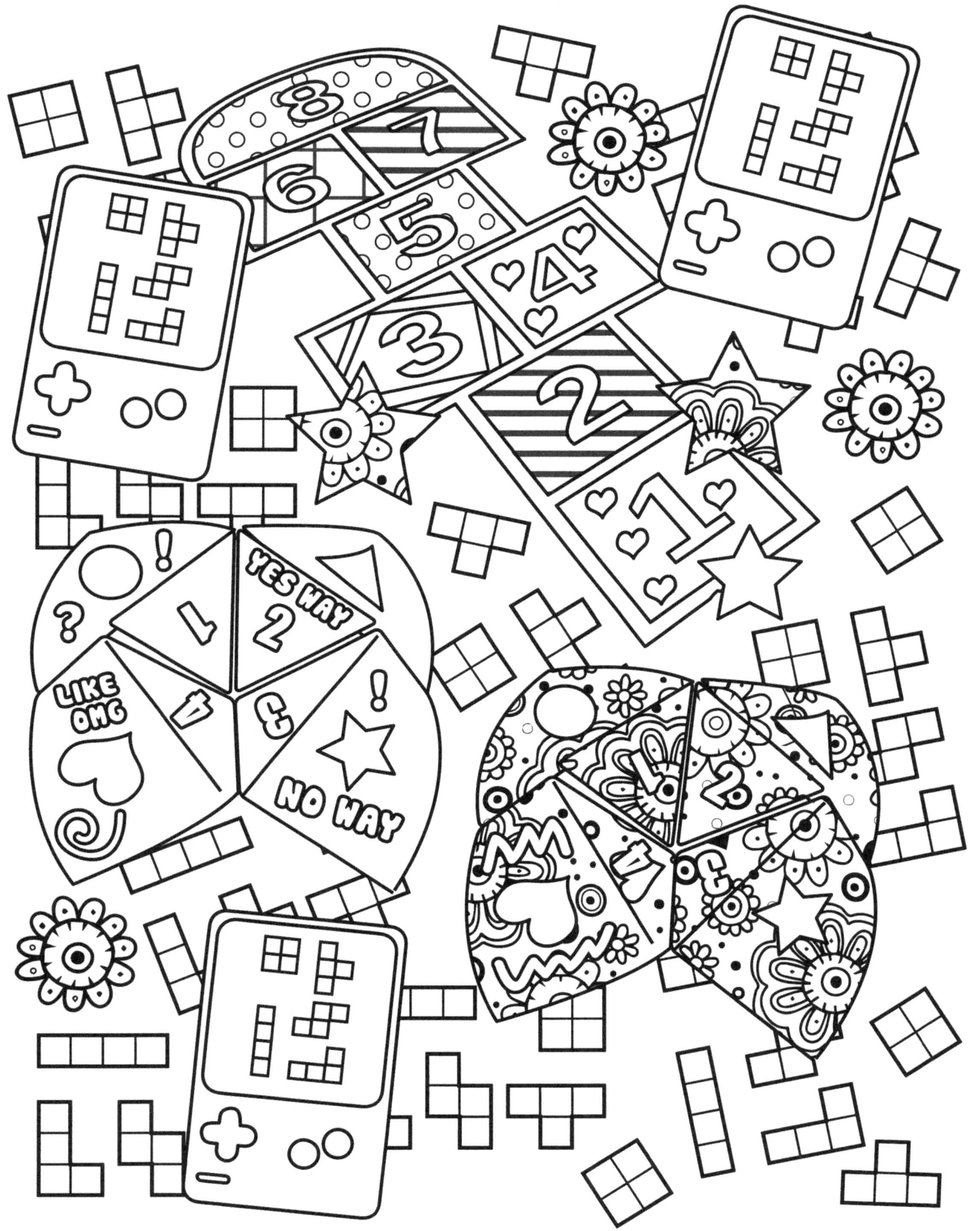

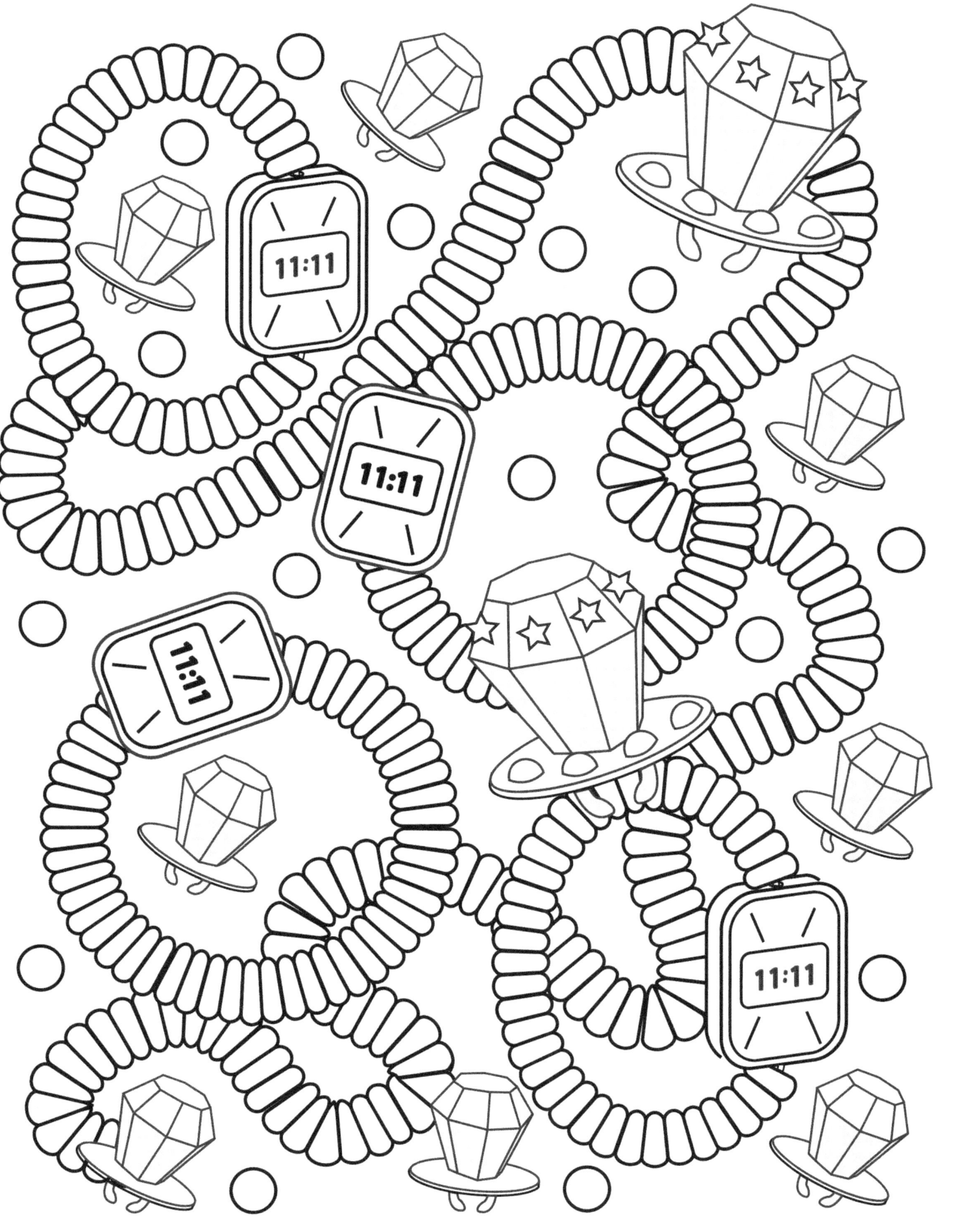

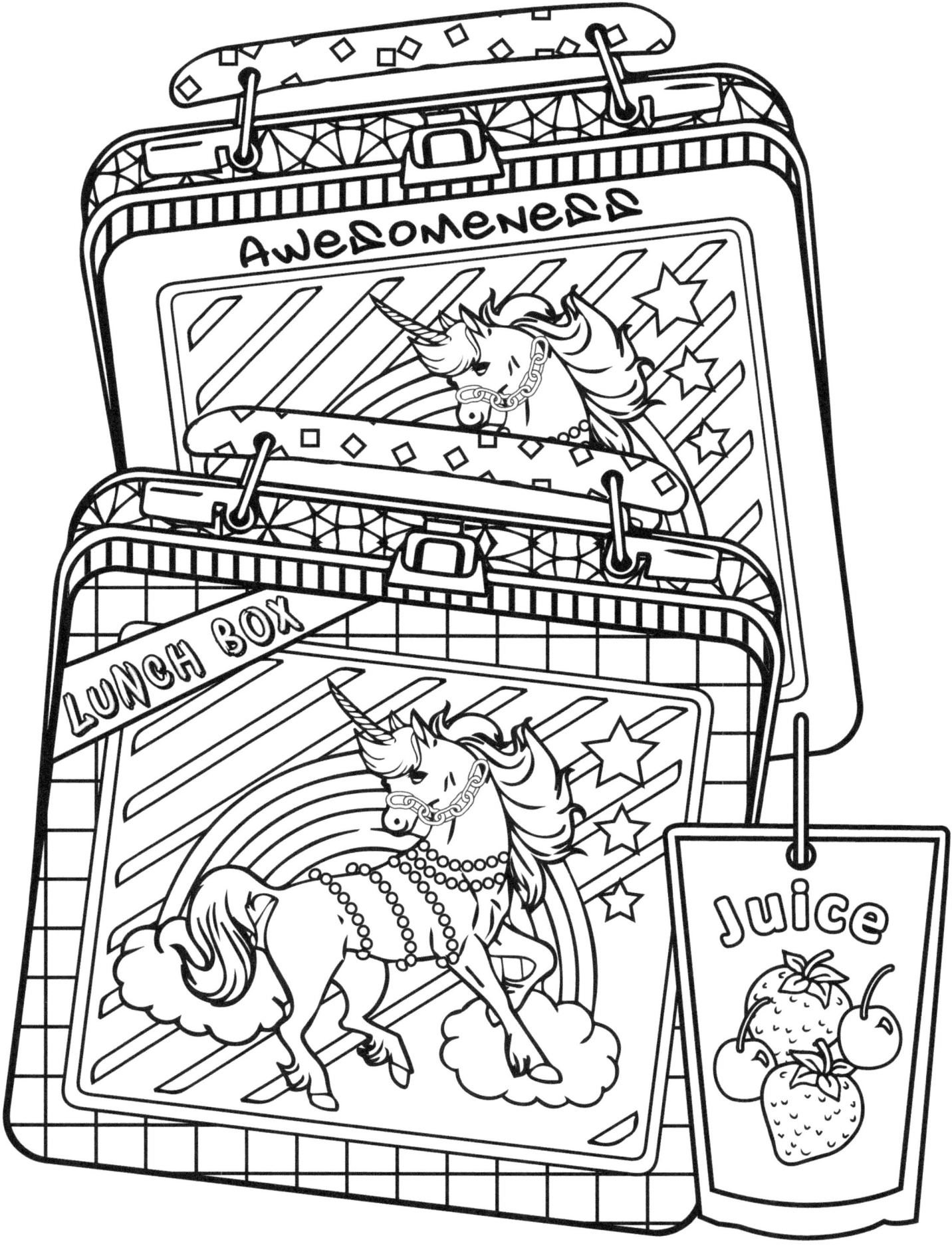

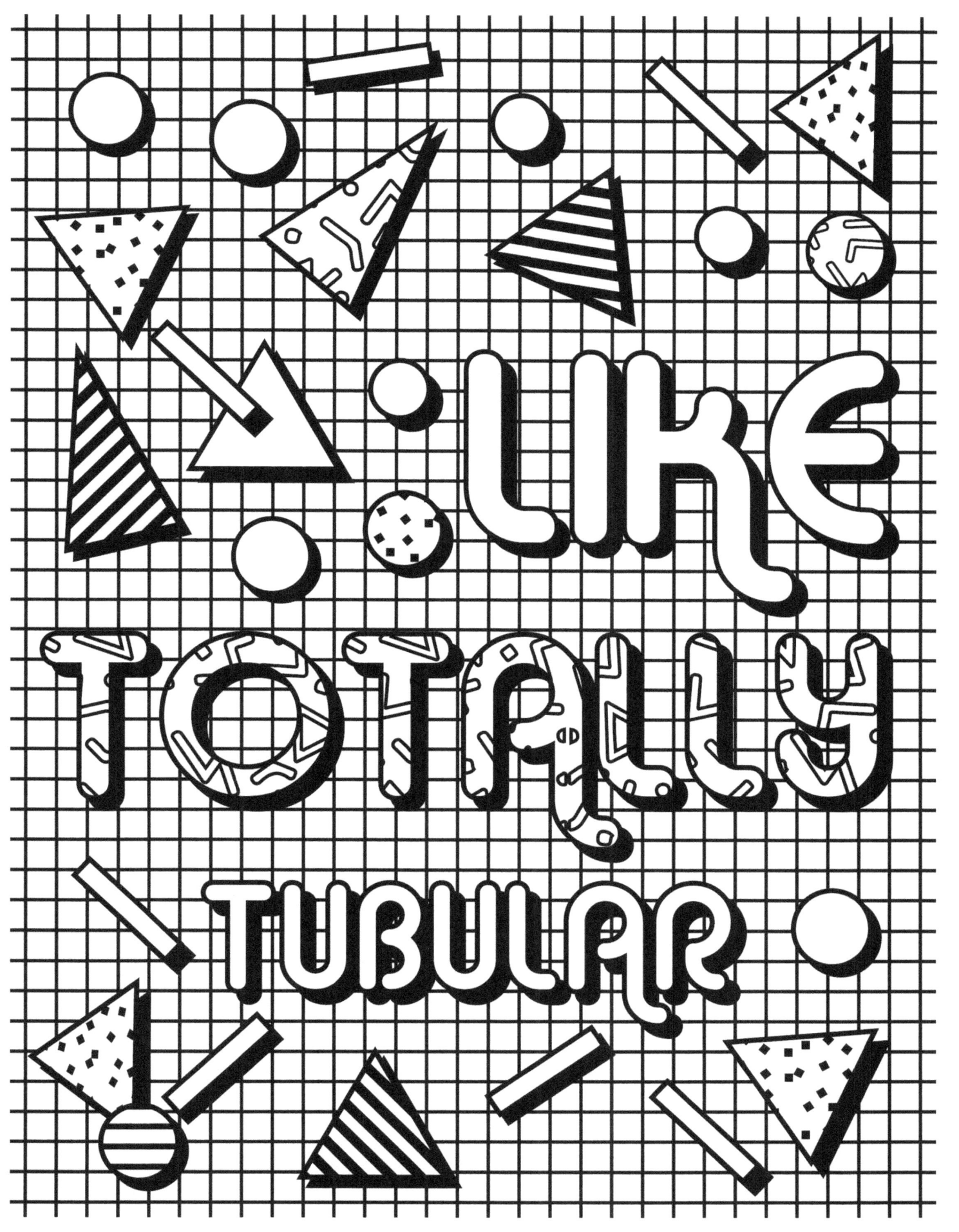

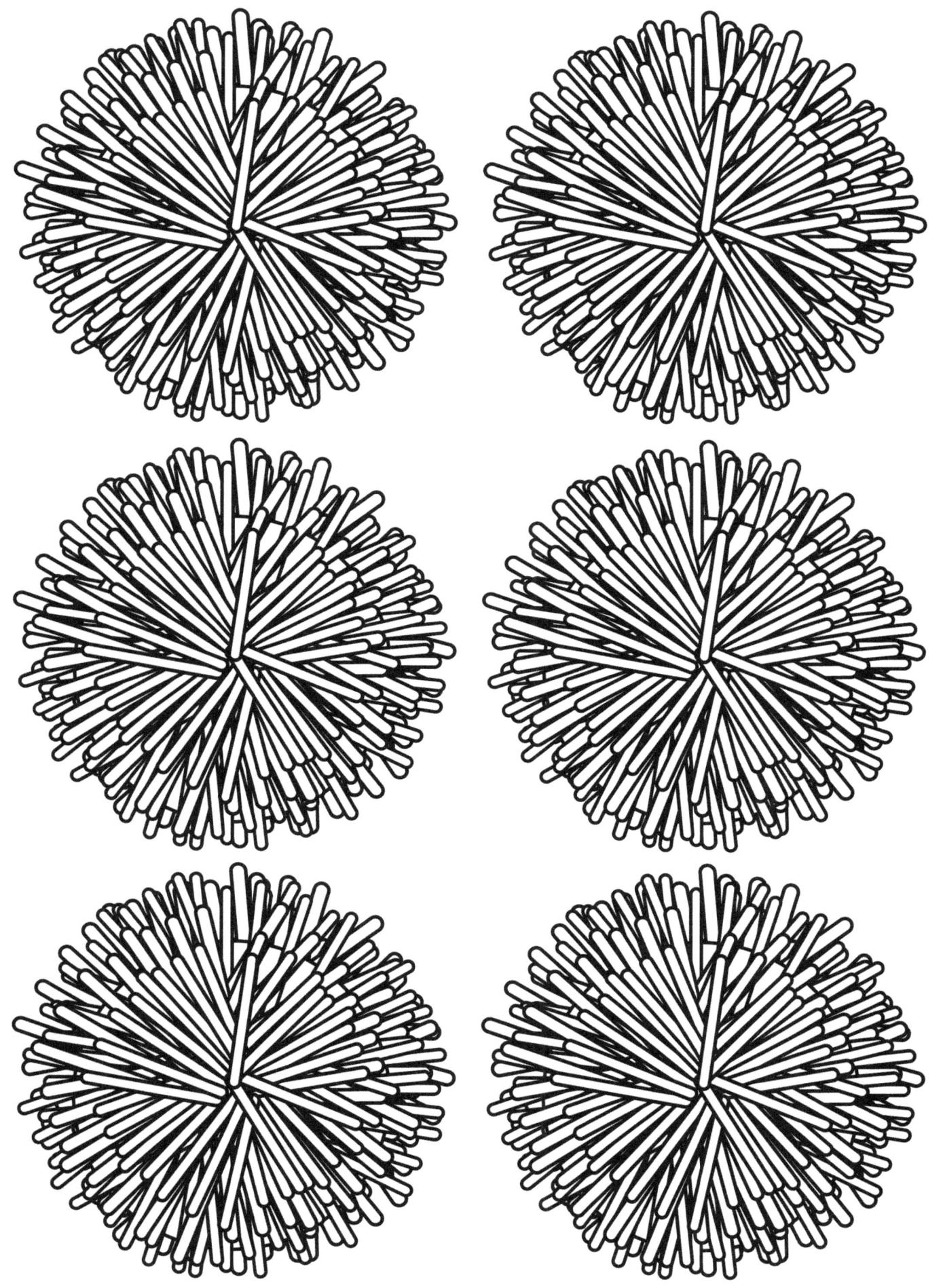

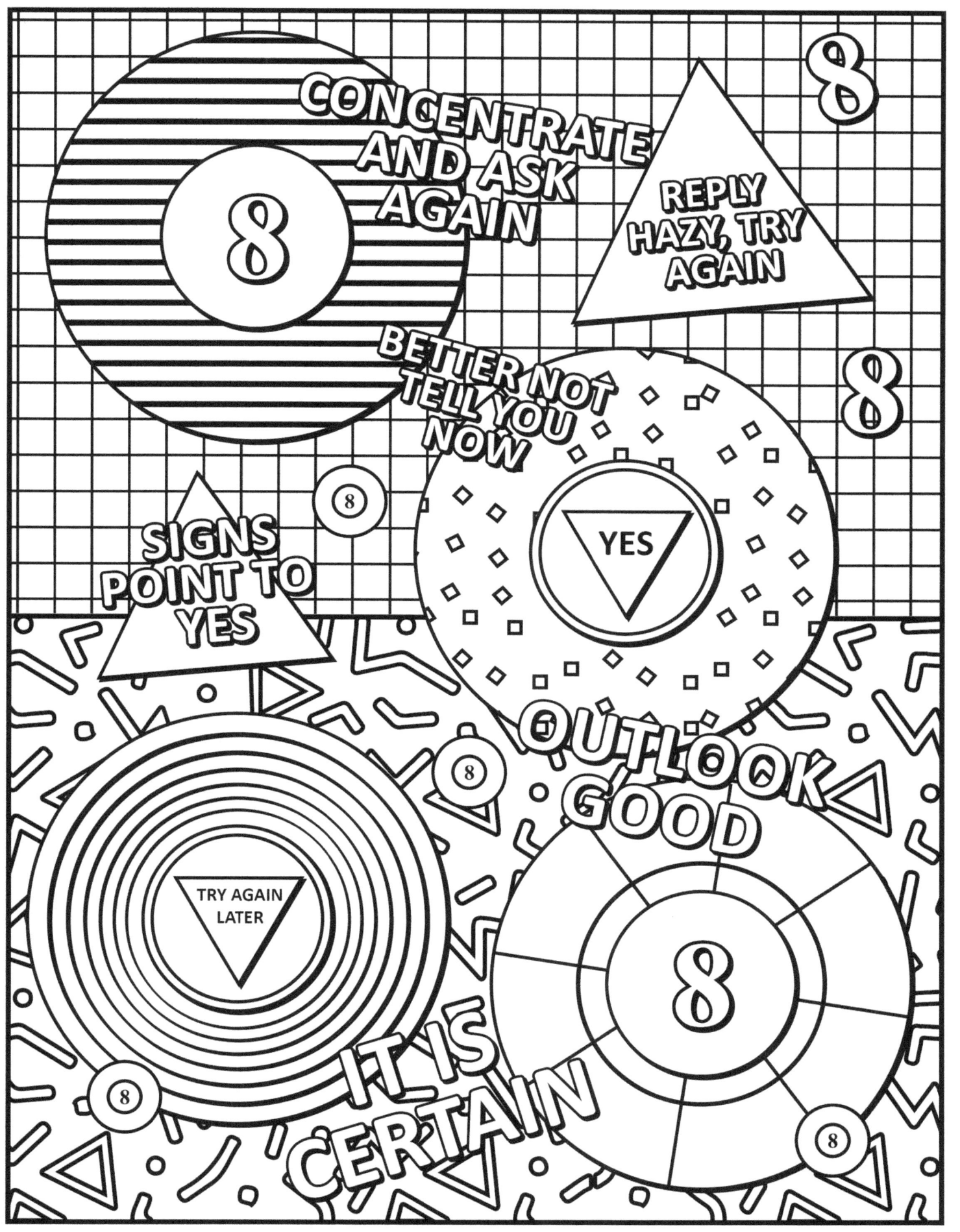

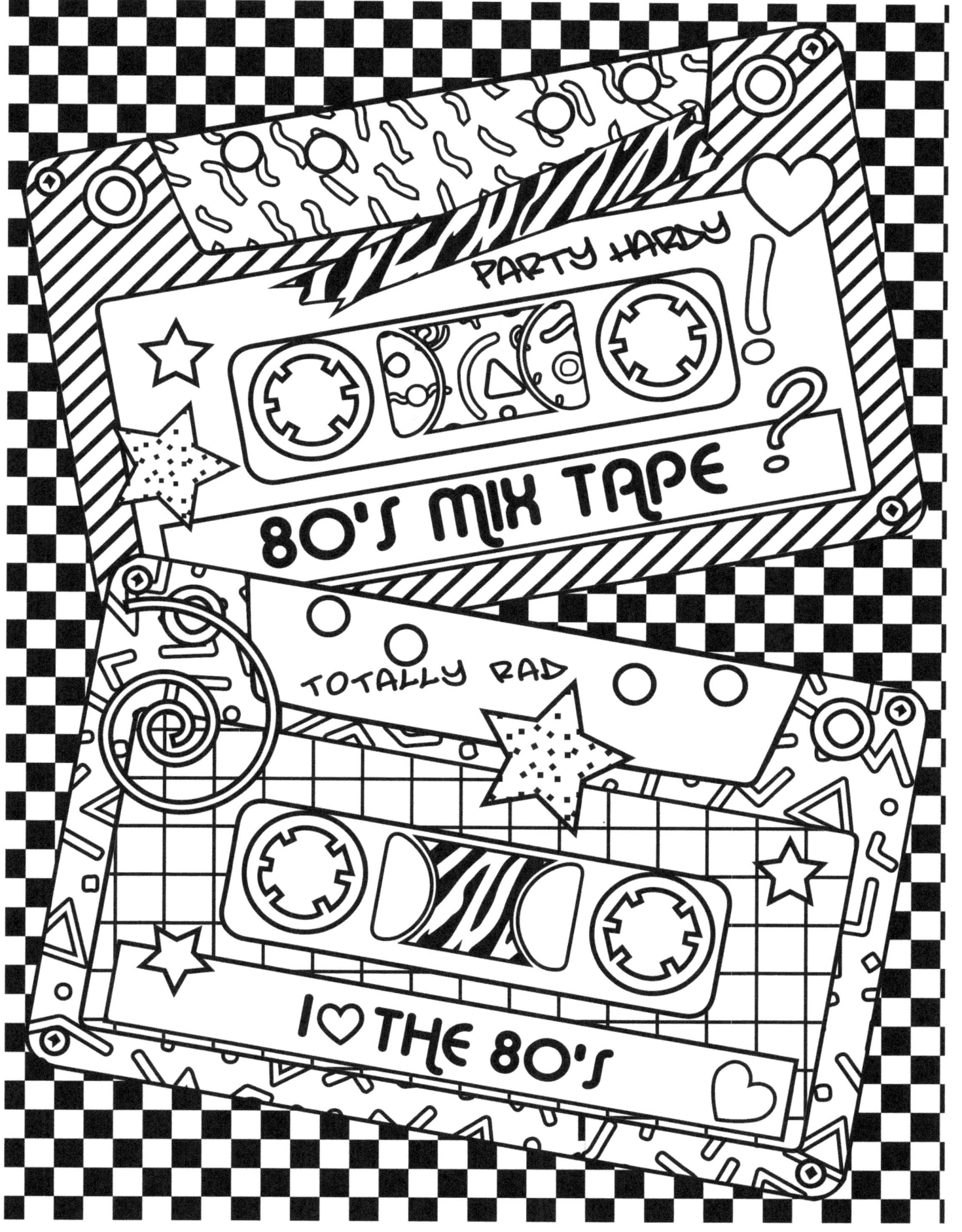

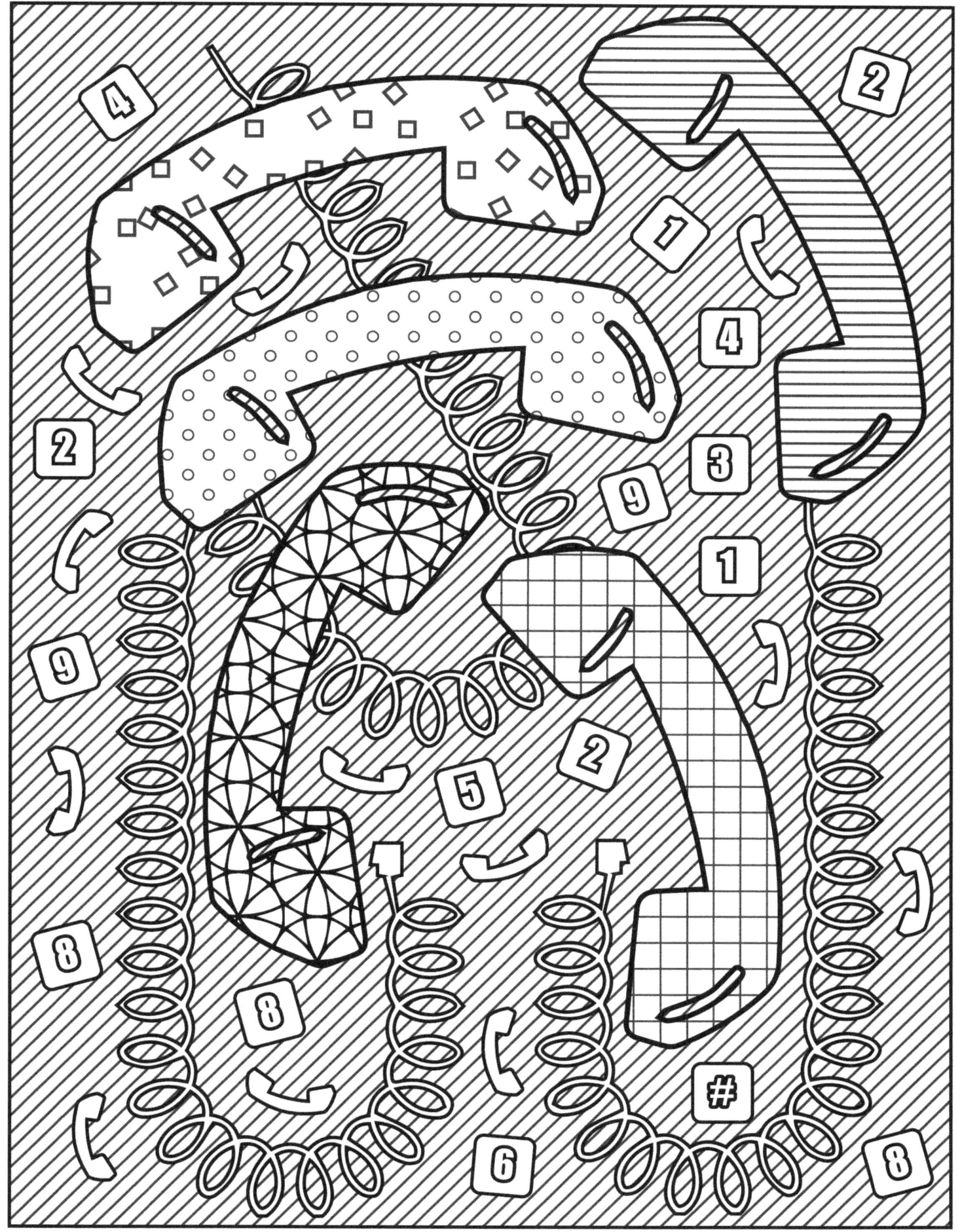

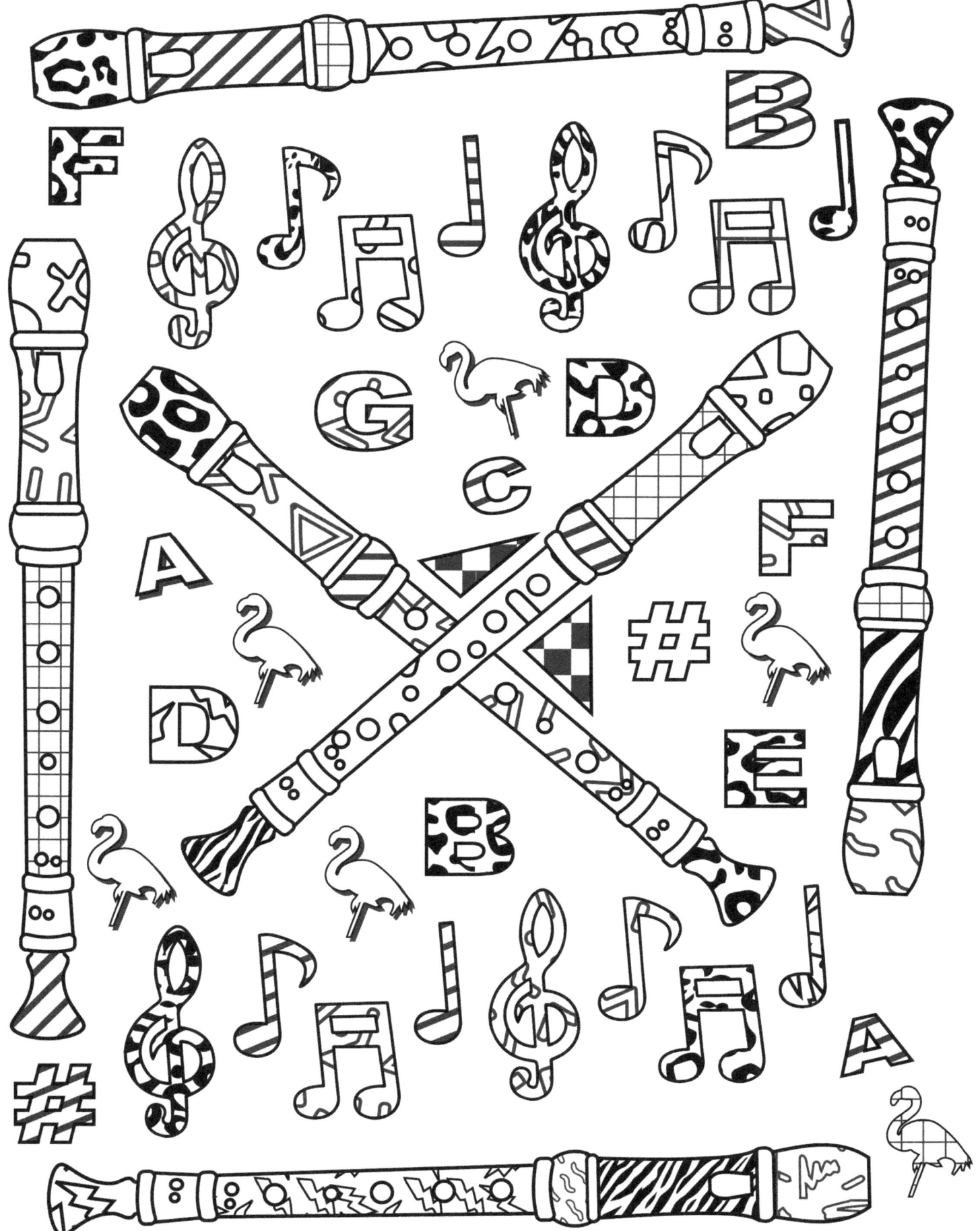

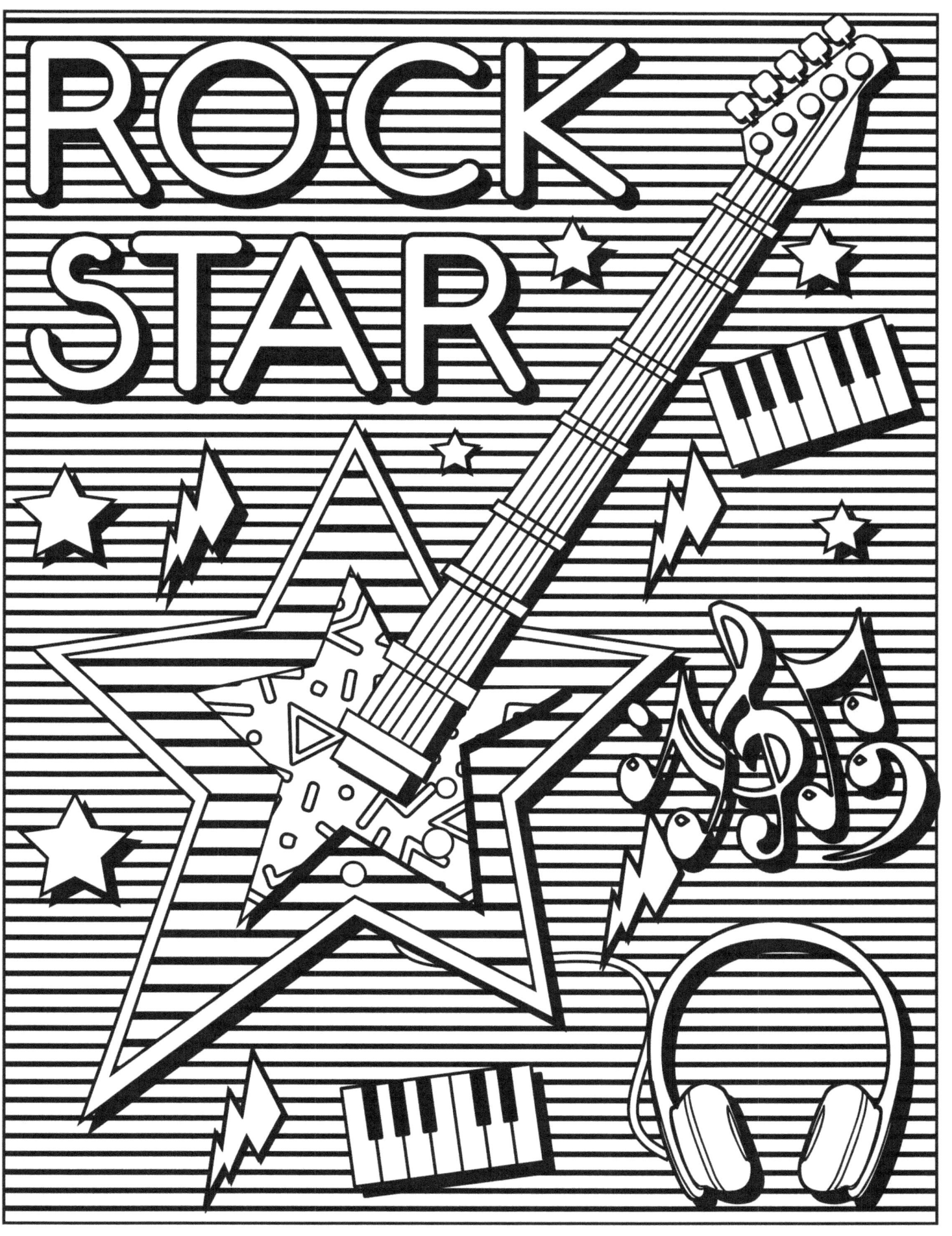

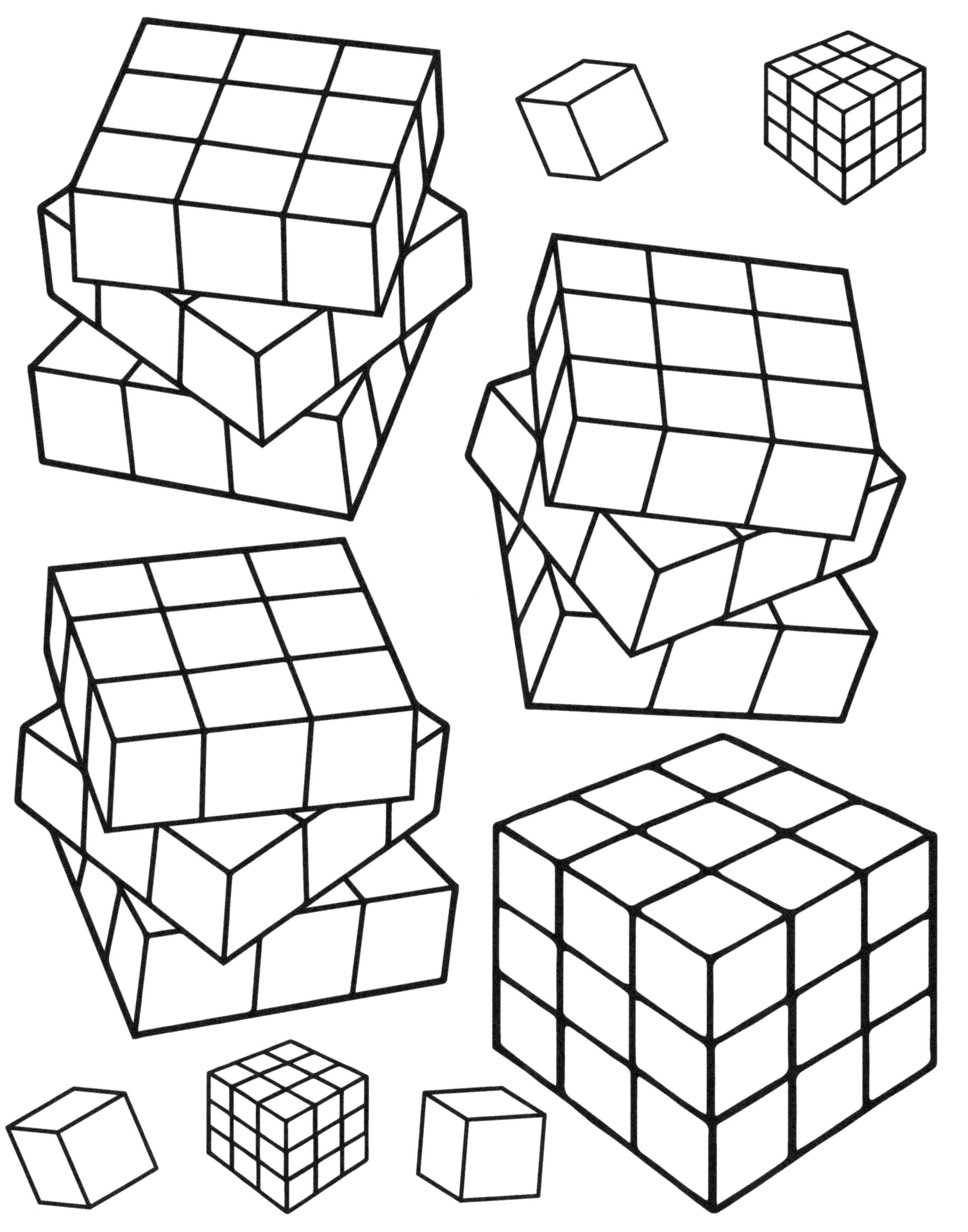

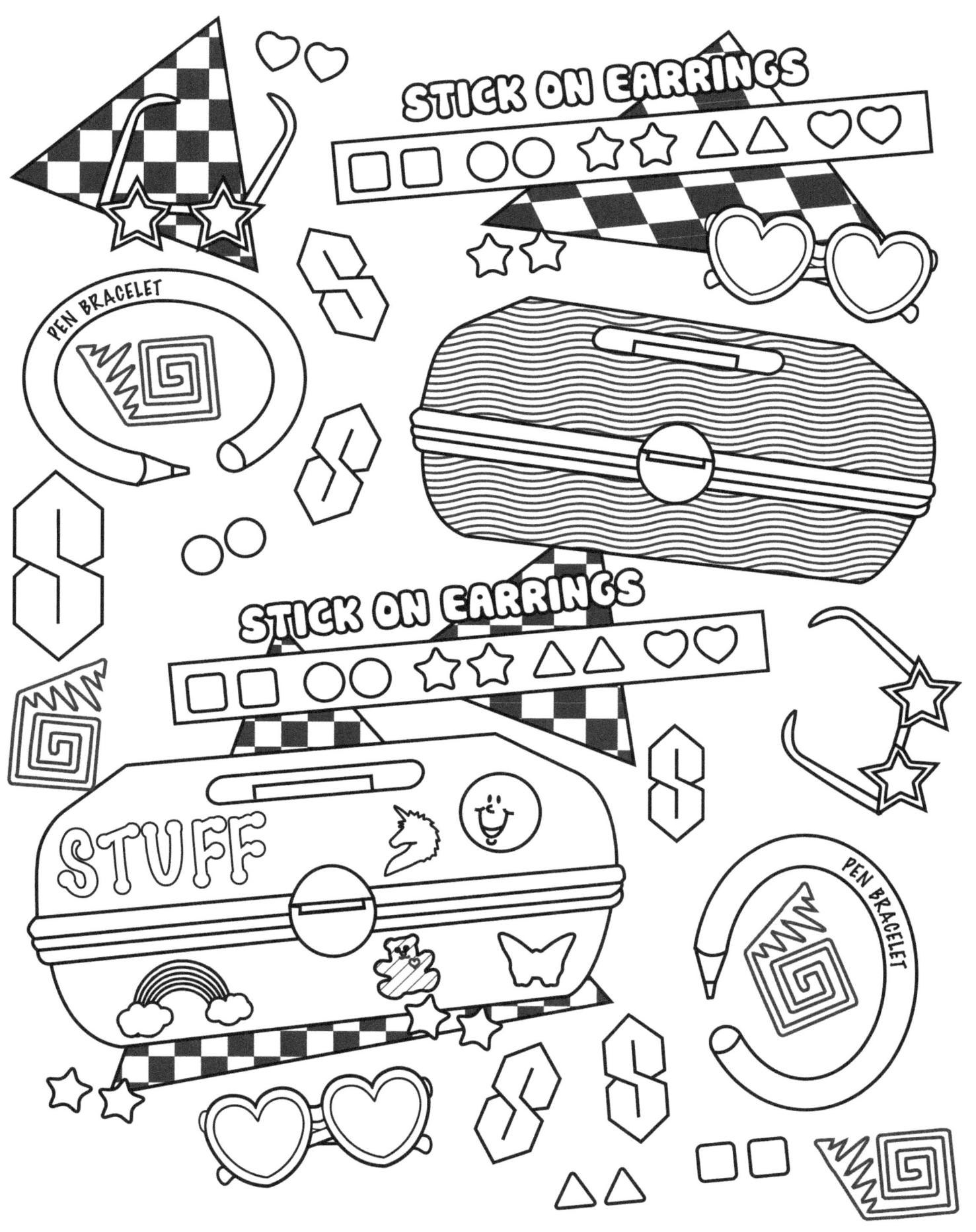

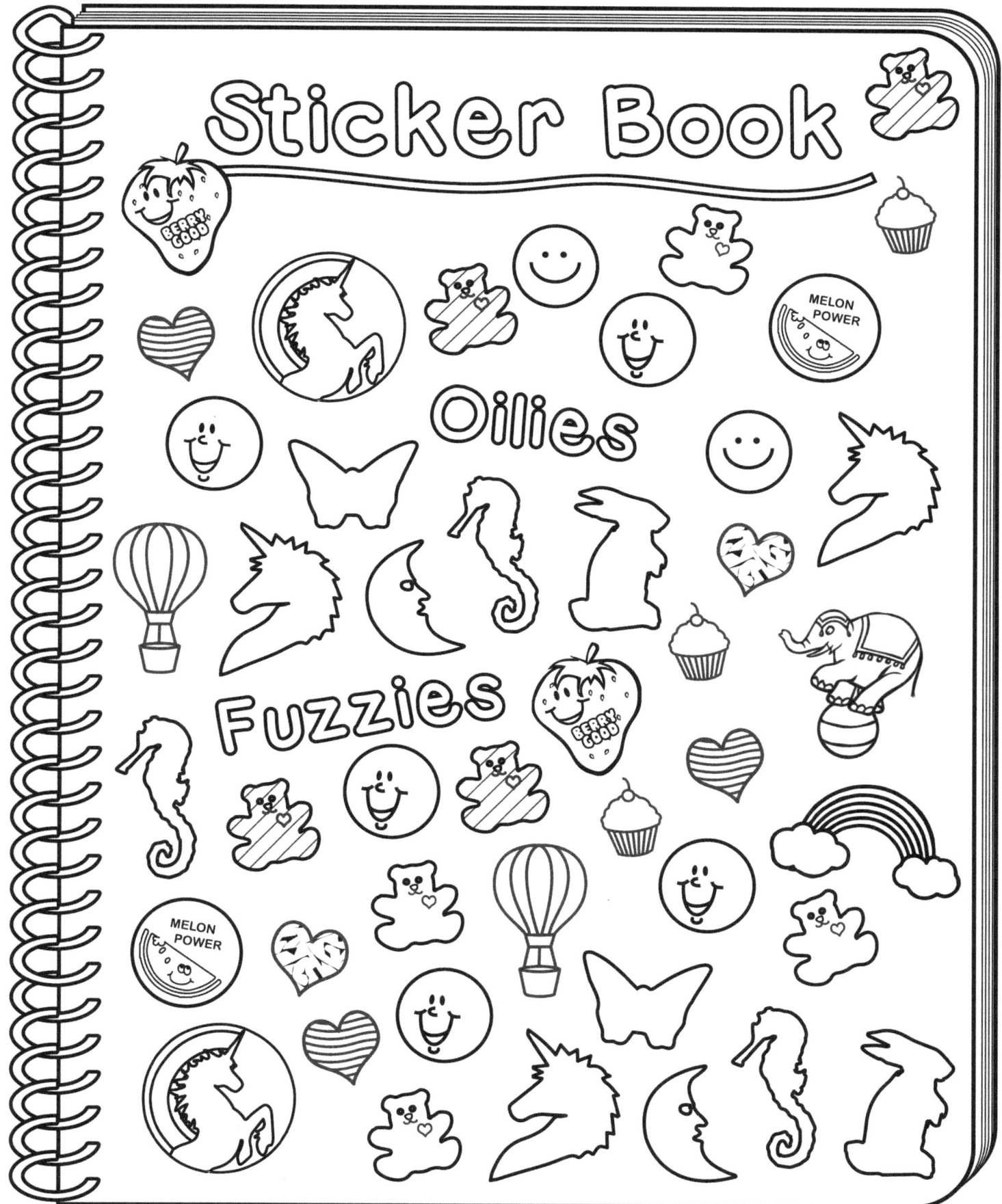

TEE SHIRT CLIPS

80's TO THE MAXX

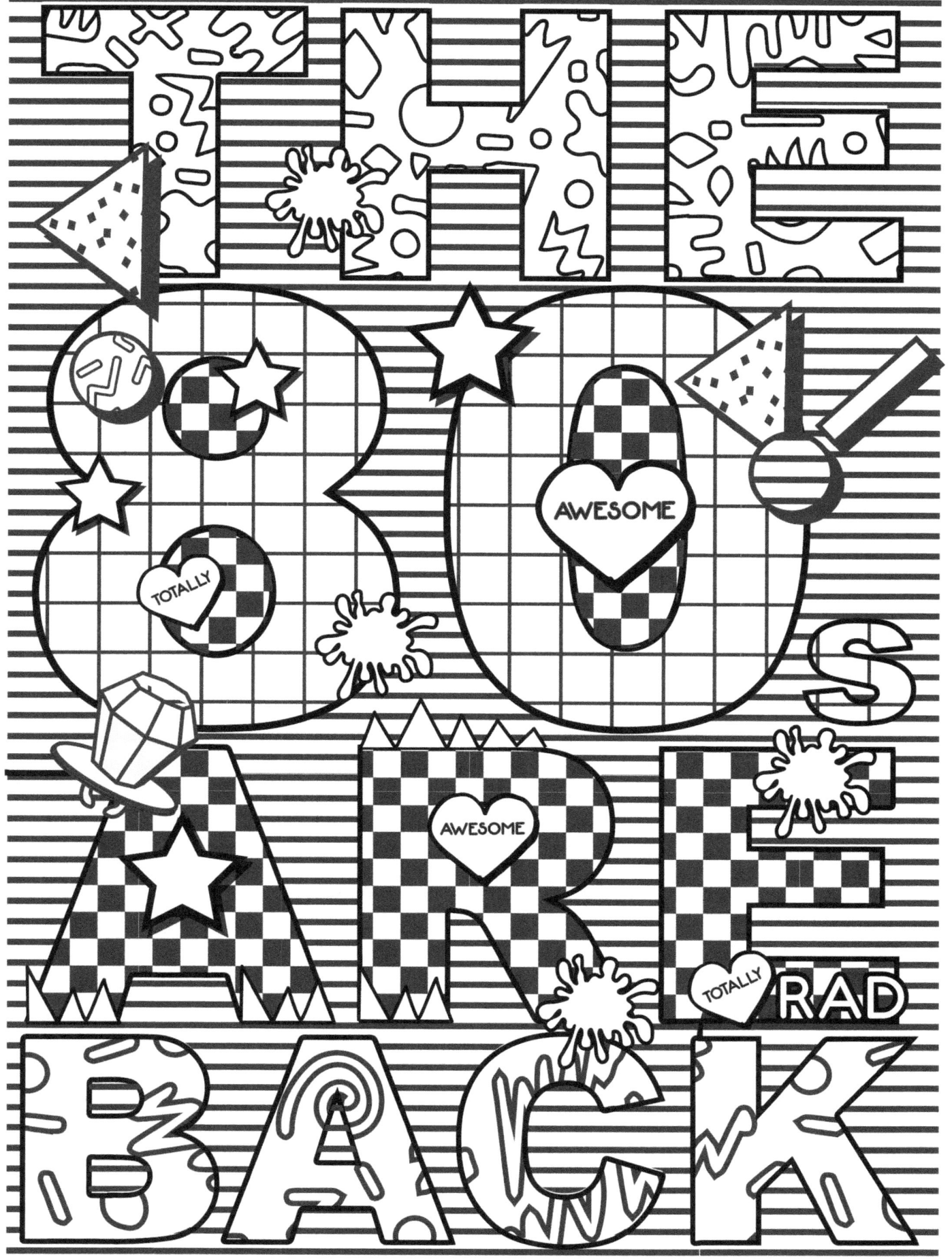

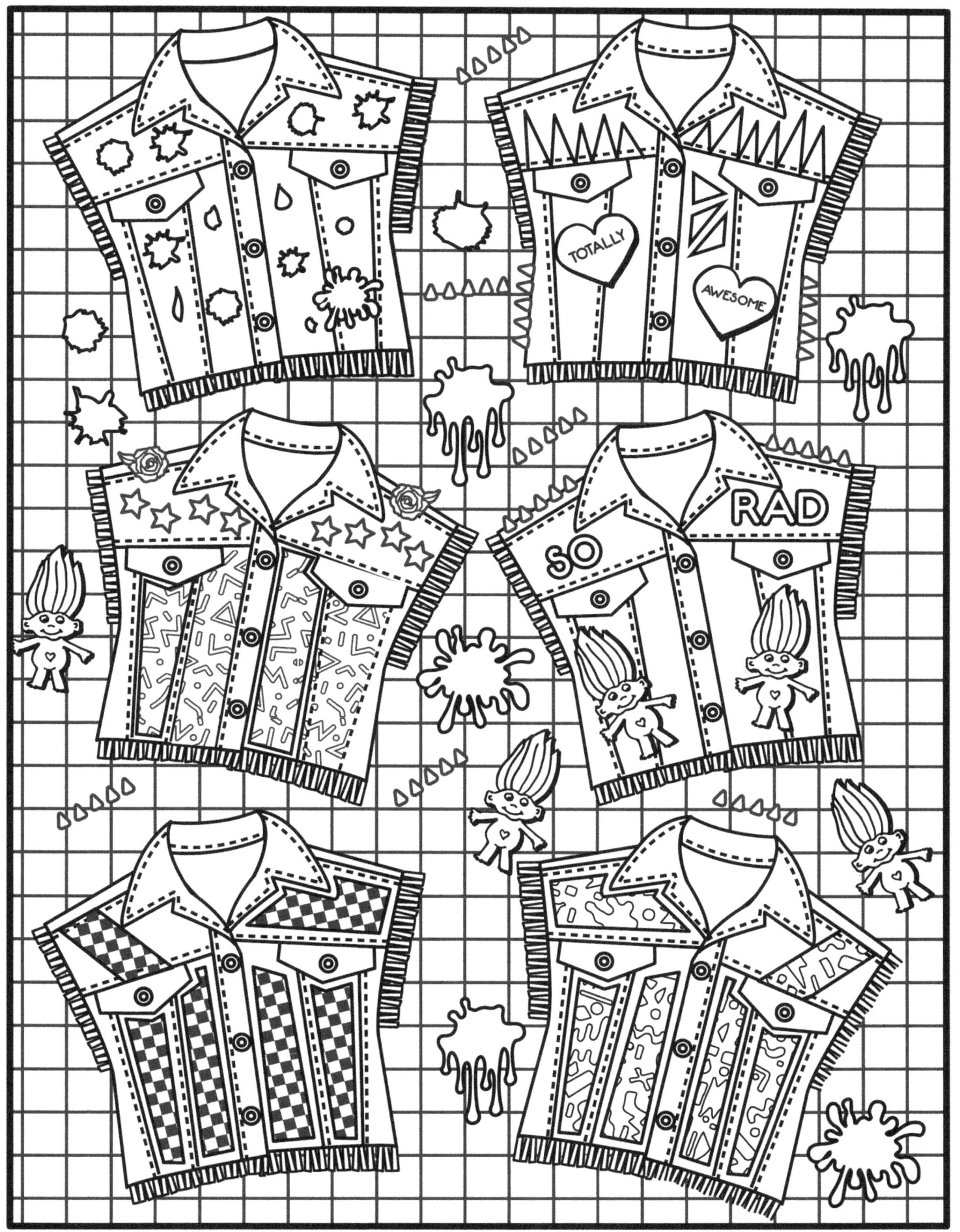

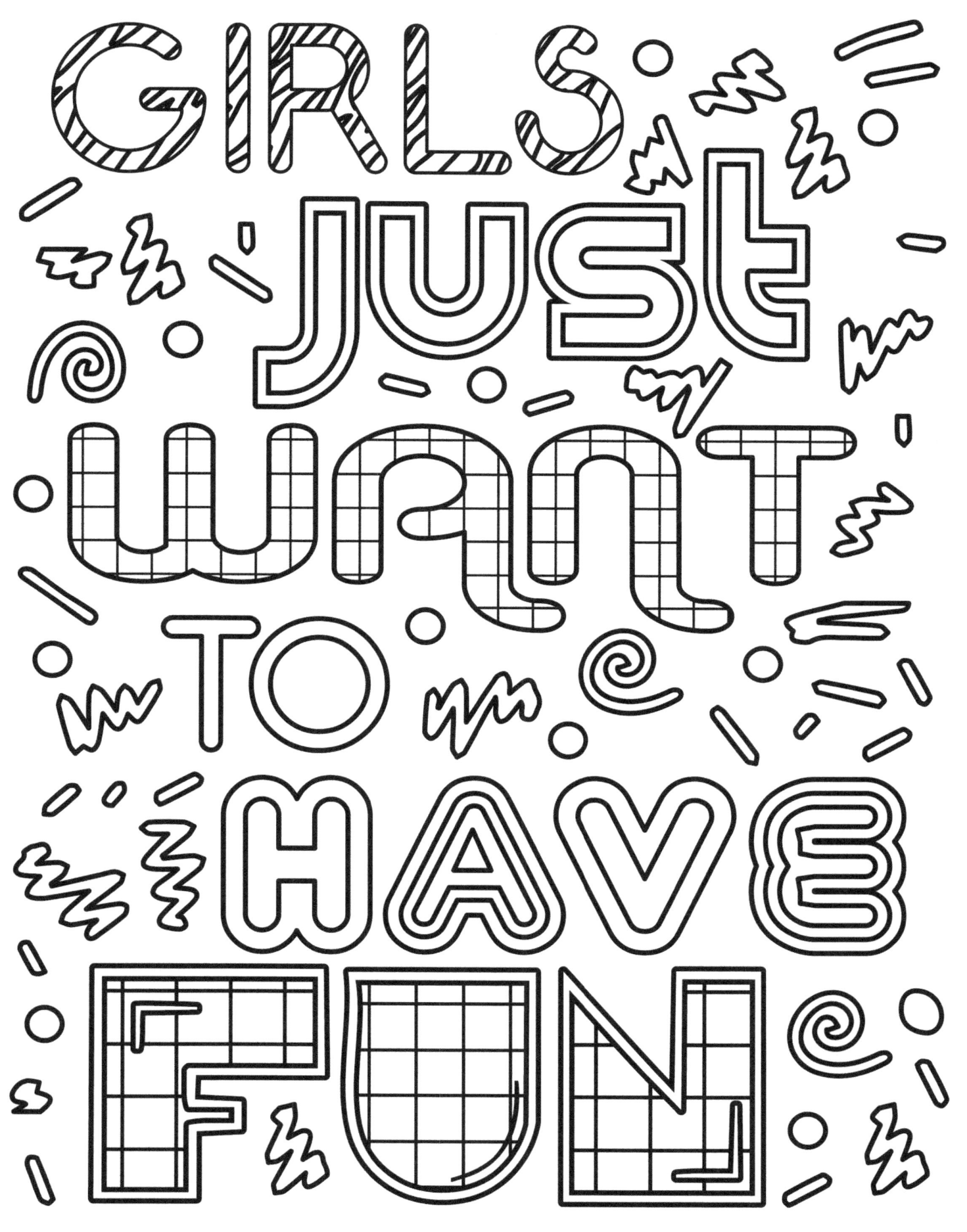

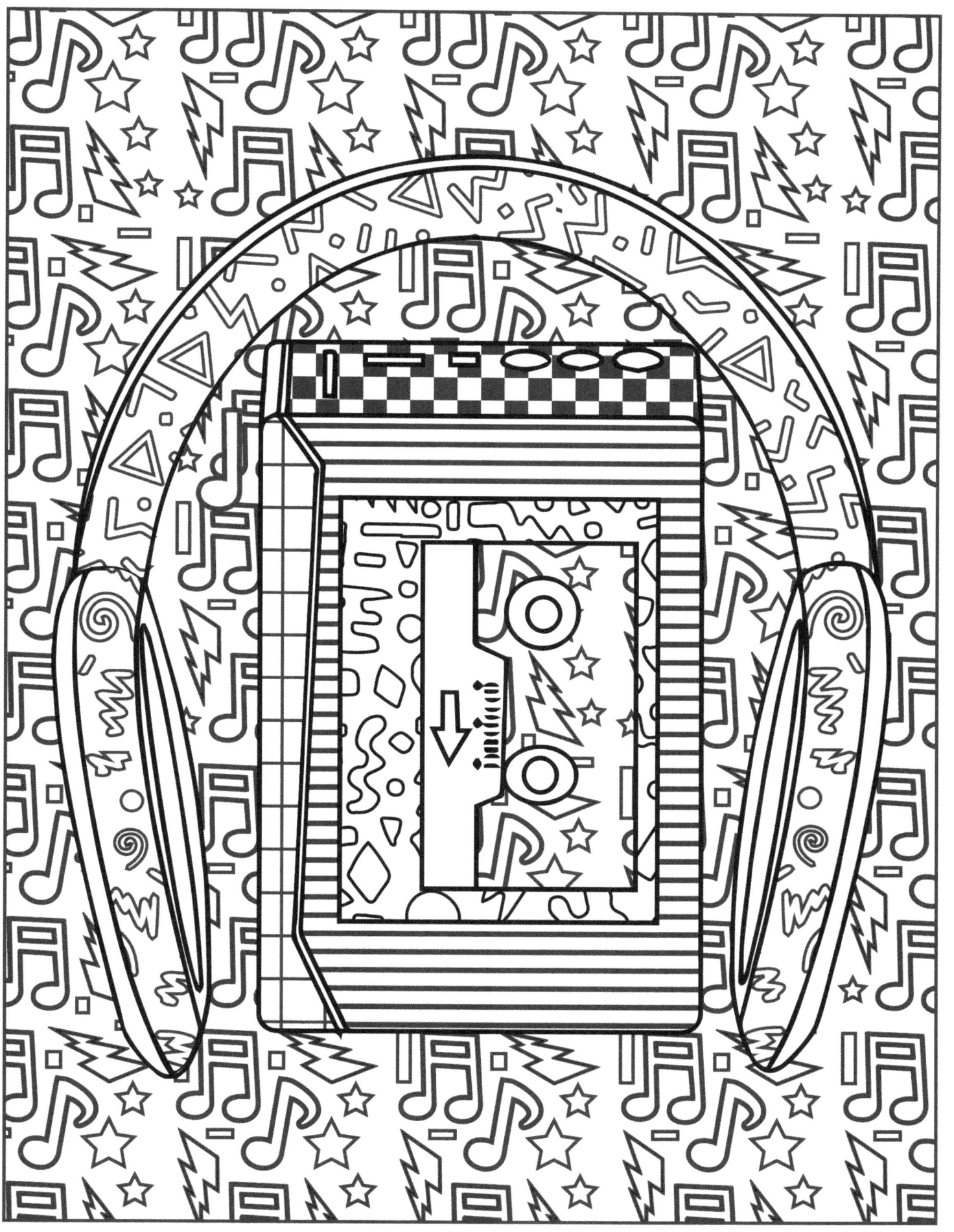

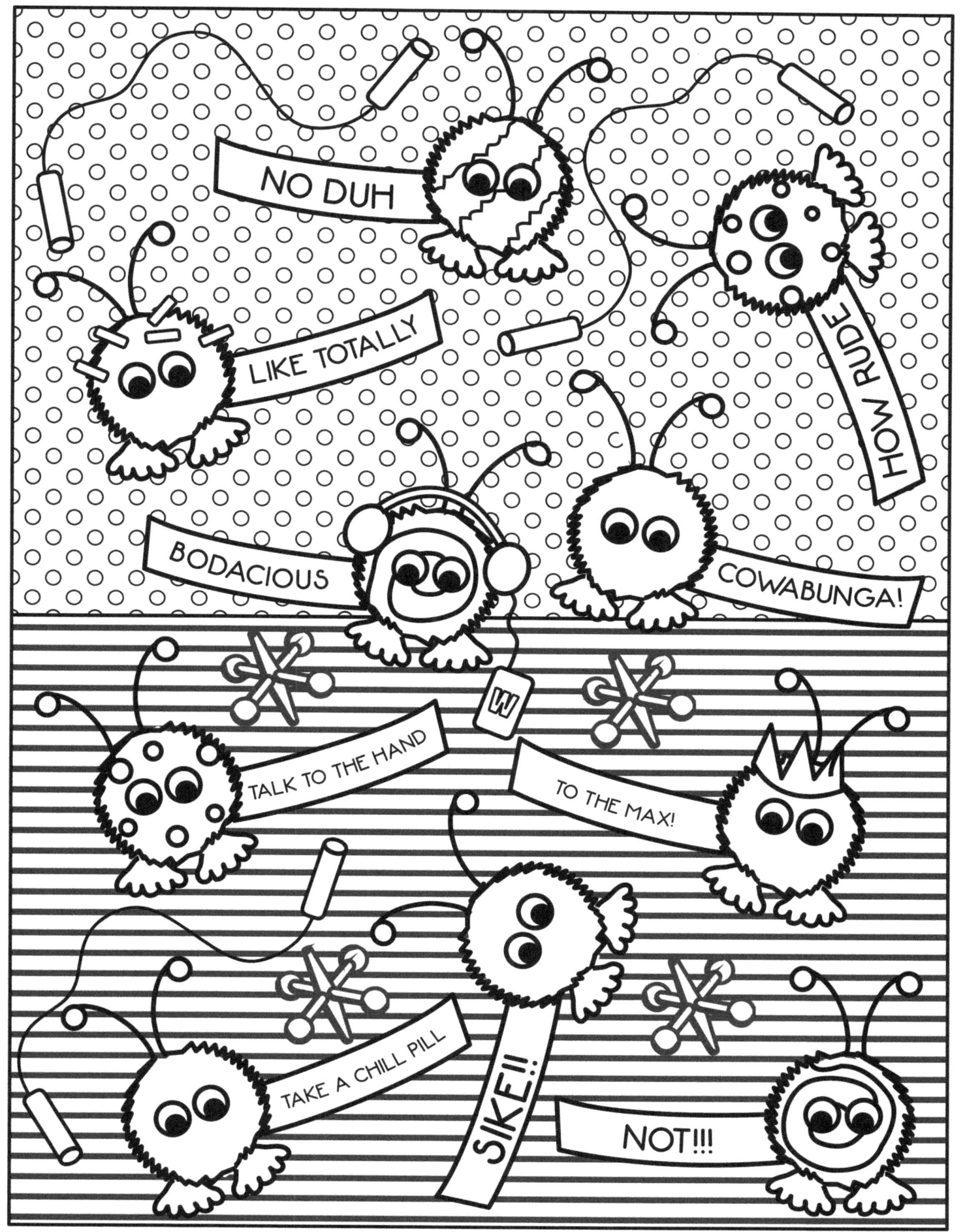

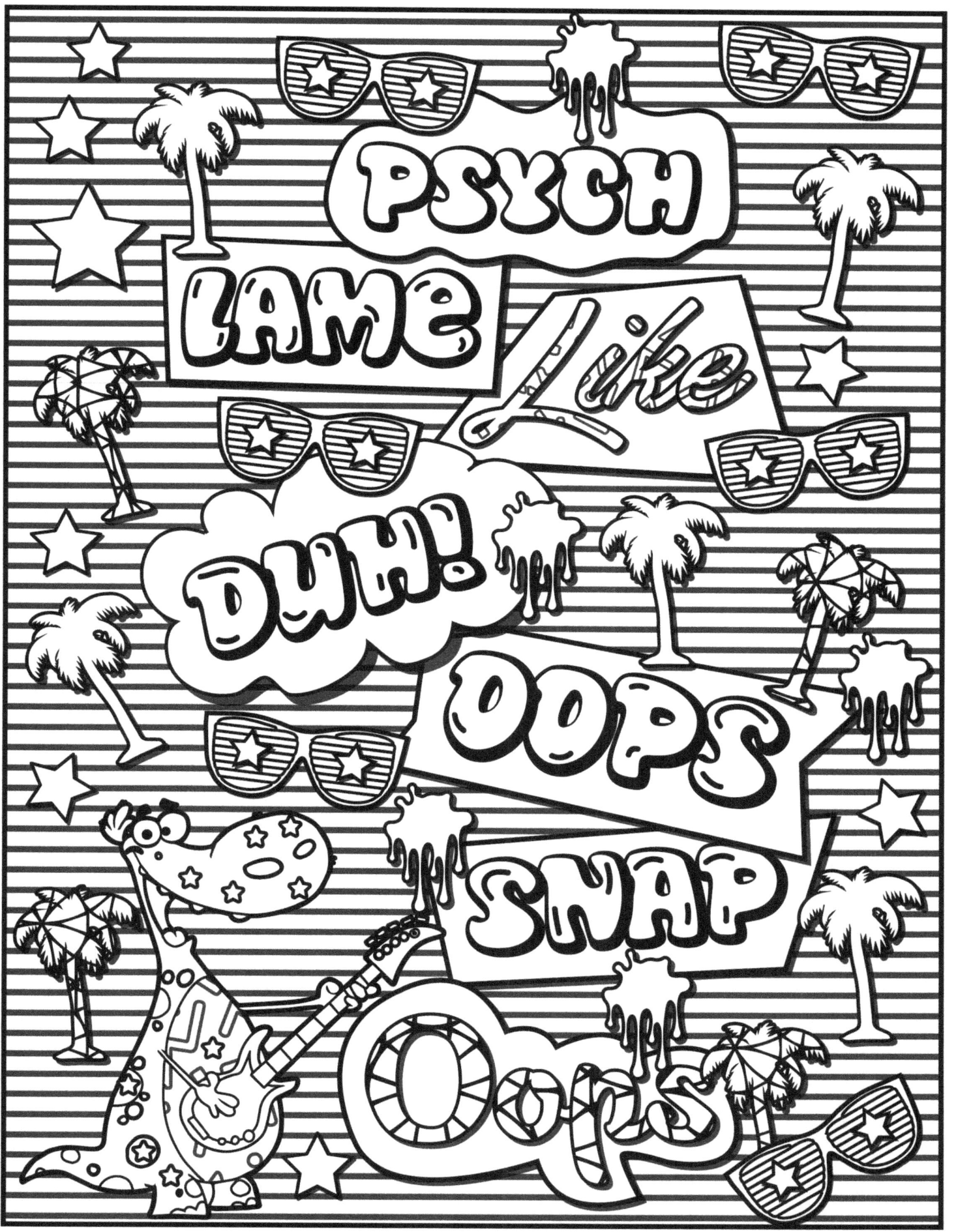

www.ingramcontent.com/pod-product-compliance
Lightning Source LLC
Chambersburg PA
CBHW080553190526
45169CB00007B/2763